FOREST ANIMALS

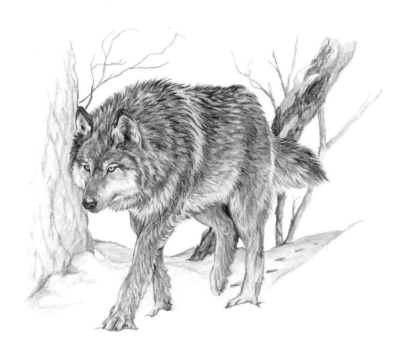

By Maury Aaseng

Brimming with creative inspiration, how-to projects, and useful information to enrich your everyday life, Quarto Knows is a favorite destination for those pursuing their interests and passions. Visit our site and dig deeper with our books into your area of interest: Quarto Creates, Quarto Cooks, Quarto Homes, Quarto Lives, Quarto Drives, Quarto Explores, Quarto Gifts, or Quarto Kids.

First Published in 2014 by Walter Foster Publishing, an imprint of The Quarto Group.
6 Orchard Road, Suite 100, Lake Forest, CA 92630, USA.
T (949) 380-7510 **F** (949) 380-7575 **www.QuartoKnows.com**

Walter Foster Publishing titles are also available at discount for retail, wholesale, promotional, and bulk purchase. For details, contact the Special Sales Manager by email at specialsales@quarto.com or by mail at The Quarto Group, Attn: Special Sales Manager, 401 Second Avenue North, Suite 310, Minneapolis, MN 55401 USA.

ISBN: 978-1-60058-380-3

Printed in China
10 9 8 7 6 5 4

CONTENTS

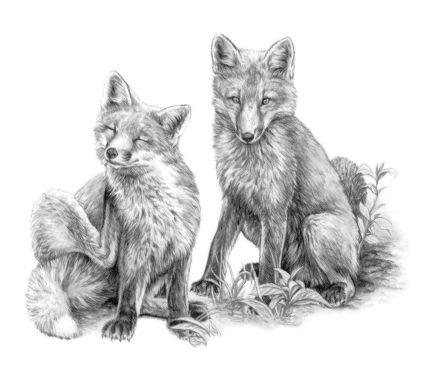

INTRODUCTION

By drawing forest animals, you have chosen an endlessly diverse subject matter as rich as the forest

itself. Many people live within a short distance of a forest of some kind, so inspiration is only a walk

in the woods away. Working in grayscale allows you the opportunity to explore the fundamentals of

mammalian design, focusing your efforts on the values, patterns, textures, and body mechanics of your

furry models. In this book, I will show you how to create the basic outlines that give different animals

in various poses their form and, often, their personality. Through a series of steps, I will help you bring

them to life with simple drawing tools and a variety of hints and techniques. Using my notes as a

guide, you can create drawings of any of your favorite animals in a way that suits your own style.

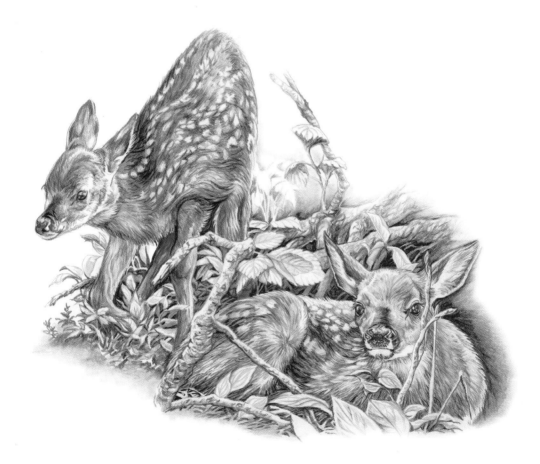

TOOLS & MATERIALS

Pencils

Drawing pencils contain a graphite center and are sorted by hardness, or grade. Soft pencils (labeled "B") produce strong, black tones. Hard pencils (labeled "H") create lighter marks. The higher the number that accompanies the letter, the harder or softer the lead. For example, a 4B pencil is softer than a 2B pencil. HB and F pencils are used for middle grades. In this book, I use a range of pencils including: 6B, 5B, 4B, 3B, 2B, B, HB, H, 2H, and 4H. I also use mechanical pencils with fine points that range in hardness and softness for detail work.

Erasers

There are a variety of erasers available. I like to use regular rubber erasers and kneaded rubber erasers. Kneaded rubber erasers are pliable and can be molded into any shape. They are great for picking tone up off the paper or creating highlights. Regular rubber erasers are good for general erasing and large areas.

Craft Knife

I like to use a craft knife to cut angular slices off my rubber eraser, which I can use to erase fine lines.

Blending Stumps

These paper tools, also called "tortillons," can be used to blend and soften pencil strokes in areas where your finger or a cloth is too large. You also can use the side to quickly blend large areas.

Paper

Traditional drawing paper comes in three types: hot-pressed (smooth), cold-pressed (textured), and rough. You can choose your texture according to your desired look. For the detailed drawings we'll be doing in this book, smooth paper will work best. I like to use Bristol board paper. It has a smooth finish and is heavy enough to withstand pencil pressure and erasing.

BASIC TECHNIQUES

You can create an incredible variety of effects with a pencil. By using various hand positions and shading techniques, you can produce a world of different stroke shapes, lengths, widths, and weights. By studying the basic pencil techniques below, you can learn to render a variety of textures.

Hatching This basic method of shading involves filling an area with a series of parallel strokes. The closer the strokes, the darker the tone will be.

Crosshatching For darker shading, place layers of parallel strokes on top of one another at varying angles. Place the strokes closer together for darker values.

Gradating To create gradated values (from dark to light), apply heavy pressure with the side of your pencil, gradually lightening the pressure as you stroke.

Shading Darkly By applying heavy pressure to the pencil, you can create dark, linear areas of shading.

Shading with Texture For a mottled texture, use the side of the pencil tip to apply small, uneven strokes.

Blending To smooth out the transitions between strokes, gently rub the lines with a blending tool or tissue.

Negative Drawing Negative space is the area that surrounds an object. By drawing the area around an object, you can create the object's form.

Erasing Erasers can be used for more than just correcting mistakes. Try using erasers to bring out details in shaded areas or to draw lighter shapes into dark areas.

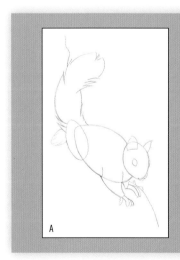

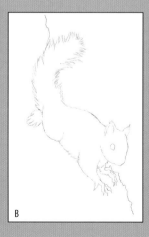

Blocking in Shapes

I always start by blocking in the most basic shapes (A). These shapes create guidelines for me as I start to develop the details (B).

CREATING FORM

The first step when creating an object is to establish a line drawing to delineate the flat area that the object takes up. This is known as the "shape" of the object. The four basic shapes—the rectangle, circle, triangle, and square—can appear to be three-dimensional by adding a few carefully placed lines that suggest additional planes. By adding ellipses to the rectangle, circle, and triangle, you've given the shapes dimension and have begun to produce a form within space. Now the shapes are a cylinder, sphere, and cone. Add a second square above and to the side of the first square, connect them with parallel lines, and you have a cube.

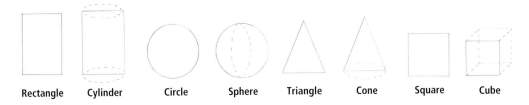

Rectangle Cylinder Circle Sphere Triangle Cone Square Cube

Adding Value to Create Form

A shape can be further defined by showing how light hits the object to create highlights and shadows. First note from which direction the source of light is coming. (In these examples, the light source is beaming from the upper right.) Then add the shadows accordingly, as shown in the examples below. The *core shadow* is the darkest area on the object and is opposite the light source. The *cast shadow* is what is thrown onto a nearby surface by the object. The *highlight* is the lightest area on the object, where the reflection of light is strongest. *Reflected light,* often overlooked by beginners, is surrounding light that is reflected into the shadowed area of an object.

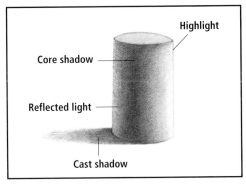

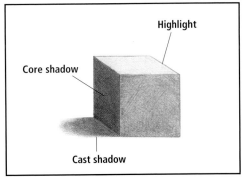

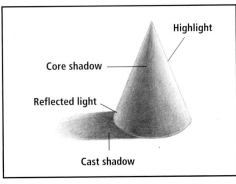

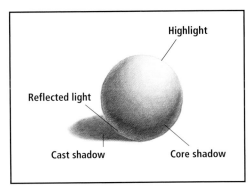

ANIMAL FEATURES

There are many unique features and textures to study when drawing wildlife. To help you get started, I've demonstrated some of the most common on the following pages. Practice with these examples before starting on a final piece. You can also use them as a starting point for other animal features that you may wish to practice.

Deer Antler

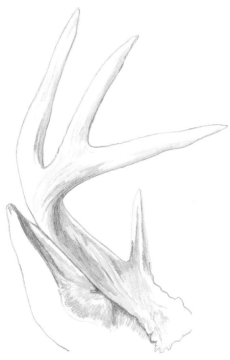

1. I use an H pencil to make a contour line drawing and map in the areas of darker values on the inside curve and underside of the antler and the top of the ear. As the shading reaches the antler prongs, I lighten the shadow to hint at the striated texture. I use an HB pencil to push a few darker values along the ear's edge, between the antler and ear, and under the curve of the antler.

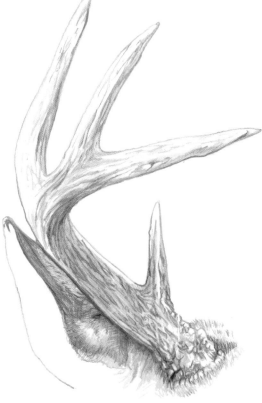

2. I use a mechanical HB pencil to darken the small ridges and grooves in the antler. I shade the bottom left edge of the bumps and nodules at the base, leaving light reflections on the top right edge. I add further value to the darks of the ear, creating tiny lines to suggest fine hairs. Note that areas in the middle of the ear are shaded lighter than the edges; this gives the ear more volume. I use an H pencil to add a series of short, parallel strokes for the hair that grows around the antler stalk.

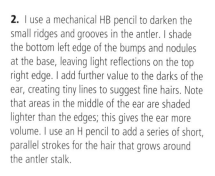

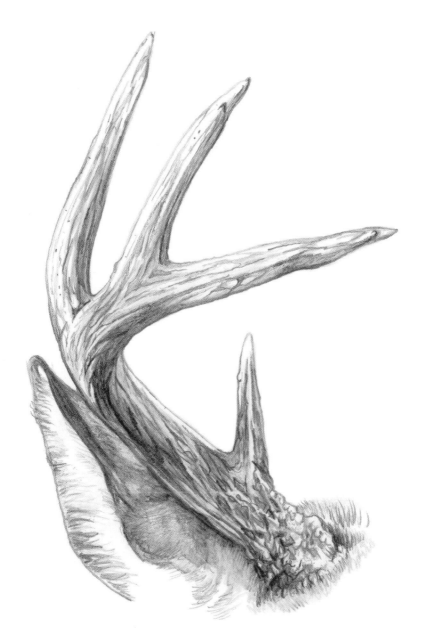

3. I continue deepening my dark values to create the cracked grooves in the antler. I darken the most within the antler's shadow (using a B pencil), and I draw light lined texture in the lighter top areas (using an H pencil). I switch to a 2B pencil to create the darkest values in the grooves under the antler's curve. Likewise, I add dark values between the ear and antler, the edge and tip of the ear, and in the antler's bumpy base. Next, using a mechanical HB pencil, I add tiny details, such as little holes in the antler bone and fine edges along of some of the grooves and bumps. I lightly shade horizontal "fur lines" extending from the middle of the ear to the outer edge with an HB pencil, pressing lightest in the middle of the ear and harder as my lines extend toward the edge. This gives the impression that the fur inside the ear is white and extends toward the darker edge.

Raccoon Ear

1. Using a 2H pencil, I sketch the upside-down acorn shape of the ear protruding from a furry head. I fringe the border with wispy strokes. At the top of the ear's center I draw a few wavy horizontal lines to map longer white hairs that hang over the inner ear opening. I shade in the dark center of the ear and extend the shading into the dark fur on the head.

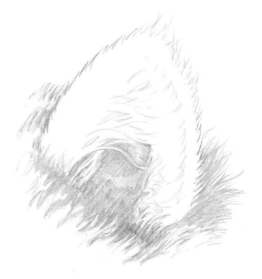

2. I use an HB pencil to darken the fur at the base of the ear and the center of the inner ear, using V-shaped clumps to avoid hard edges. I define the right outer edge of the ear and push some darker values in the fur behind the bottom right corner to "pop out" the ear. I darken the negative space between the short hairs framing the right edge of the inner ear. I extend the shading from the base of the ear up, leaving an area of white surrounding the entire inner ear. I switch to a 2H pencil to extend these shapes outward, making them lighter in value as they emerge from shadow. I further define the wavy hairs flowing over the middle of the ear, darkening areas between them and underlining the predominant strands.

3. I use a 2B pencil to push the deepest darks, pressing hard at the base of the ear to make jagged, black lines where it emerges. I leave lighter pencil strokes exposed in some areas to give the fur volume. I press deep values into the inner ear and between the patches of emerging fur and under the wispy strands. I use a kneaded eraser to pull graphite away from the wavy, overlapping strands, making them into larger "clumps" of fur instead of individual strands. I use a sharp 4H pencil to add fine strokes along the white "ring" of the ear. I also add fine strokes to the clumps of hair I partially erased. Using an HB pencil, I draw more patterns in the fur.

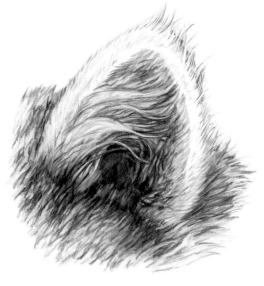

Chipmunk Paws

1. I begin with a jagged-edge contour drawing of the paws, using an H pencil. In this downward-facing view you can see the individual, splayed digits of the paws and the edges of the chest fur. I introduce just a few wavy, sharp-edged lines in the rightmost paw to get an initial feel for pattern and direction in the fur.

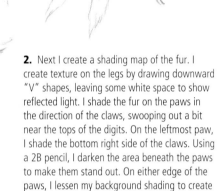

2. Next I create a shading map of the fur. I create texture on the legs by drawing downward "V" shapes, leaving some white space to show reflected light. I shade the fur on the paws in the direction of the claws, swooping out a bit near the tops of the digits. On the leftmost paw, I shade the bottom right side of the claws. Using a 2B pencil, I darken the area beneath the paws to make them stand out. On either edge of the paws, I lessen my background shading to create just a hint of bark pattern that fades out.

3. I create shadows in the fur using a variety of pencils. I use an H pencil to draw strokes in the lighter areas between fur clumps (such as on the upper arm and the tops of the toes). As I work into the darker areas in the middle of the foot and leg, I switch to an HB pencil. At the bottom edges of the toes, and where the shadows between patches are deepest, I use B and 2B pencils. I use dark values on the right and bottom edges of the claws and leave the strands of fur that overlap them unshaded for contrast. I use a blending stump to smooth the pencil strokes on the wood beneath the paws. Then I use a mechanical HB pencil to lightly draw grooves in the bark to give the log realistic texture.

Predator Eye

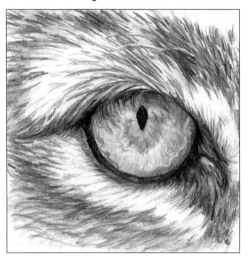

The focal point of this bobcat eye is the diamond-shaped pupil.

- Shade the dark pupil with a 6B pencil.
- Use an H pencil to fan short strokes out from the pupil.
- Shade the dark eyelids with a 2B pencil, using less pressure for the lighter areas in the lower lid.
- Use a 2H pencil to create the fine lines in the white fur around the eye.
- Use softer graphite pencils to create patterns in the darker fur.
- Create dark fur shadows at the top of the eye.
- Pull out highlights with the corner of an eraser.

Prey Eye

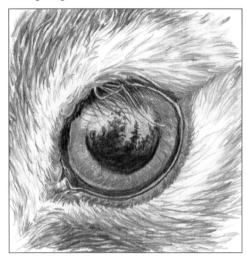

The shape of this cottontail rabbit's eye is like a fat seed, tilted at a 45-degree angle.

- Use a 2B pencil to create the outer black edge and fill in the pupil.
- Use an HB pencil to create subtle striations in the iris and the bit of skin around the eye. Leave a thin light area around the eye to create the lid and tear duct.
- Add fur lines around the eye with an HB pencil for dark fur and a 2H pencil for white fur.
- Add dark lines on the eye with an HB pencil for the fur shadows.

Button Nose

A common nose type for forest animals is a dark "button" nose—relatively smooth and hairless.

- Sketch the mushroom shape of the nose and draw tiny bumps with a 2H pencil.
- Shade between the bumps with a B pencil.
- Shade the nose again with a 4B pencil, concentrating on the middle of the nose and the nostrils.
- Create fine, light fur that radiates from the nose with an H pencil.
- Use a B pencil to create patterns in the fur, with the deepest values where the mouth meets the muzzle.

Furry Nose

Some forest critters, such as porcupines and beavers, have furry snouts.

- Sketch a butterfly shape to place the nostrils and lightly shade with a dull B pencil. Leave a small band around the nostrils unshaded.
- Add light gray shading to the rest of the snout and blend the lines to soften the value gradients.
- Use a sharp H pencil to create the fur radiating out from the nose.
- Use a B pencil to add detail in a midtone value, giving the form more volume.
- Create the tiny areas of darkest shading between fur clumps and at the top of the nostrils with a 4B pencil.
- Use a dull B pencil to create shapes and areas of value in the nostrils for additional texture.

Whiskers

Creating whiskers is almost entirely an exercise in negative space.

- Draw the edge of the jaw. Then lightly map out the whiskers with a 4H pencil.
- Shade between the whiskers with 2 and 4B pencils.
- Erase any accidental shading over the whiskers with a gum eraser.
- Add darker whiskers on the right side of the drawing with sweeping pencil lines.

Note: Some whiskers are dark in color, in which case you can use a skinny pencil stroke.

Coarse Fur

Coarse fur can be sparse, but the strands are thicker and tend to lay irregularly.

- Draw diamond-like patterns to form the area between hairs with a 2H pencil.
- Start drawing lines on the underside of the largest fur strands with a 2B pencil.
- Add more lines and smaller clumps of fur in the spaces between the large fur strands with an HB pencil.
- Use a 2B pencil to deepen the darkest shadows.
- Slice an edge out of a gum eraser and use the pointed corner to trace the long fur strands, lifting out graphite.

Fine Fur

Many small forest animals have dense fur coats consisting of hundreds of thousands of fine strands of hair.

- Avoid overshading the white fur by using a 4H pencil to draw wavy lines.
- Use an H pencil near the border of darker fur, leaving areas of white to create volume.
- Use the side of a dull HB pencil to shade the dark fur, and then blend with a stump.
- Sharpen the HB pencil and draw clumps of fur in a series of patterns.
- Add dark strokes on the underside of some fur with a 2B pencil.

Matted Fur

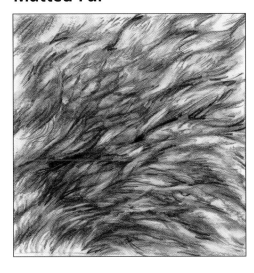

Thick, matted fur can be challenging, but the key is to look for patterns of light and dark.

- Use a light graphite pencil to sketch the outline of fur clumps.
- Lightly shade between the clumps with the side of a dull B pencil.
- Use a blending stump to push and pull graphite around the clumps, leaving the centers of each shape with the lightest value.
- Draw fine, short lines with an HB pencil to create hair texture in the light areas.
- Use a 4B pencil to deepen the darkest areas, separating clumps of fur.
- Add extra lines as needed for texture or detail.
- Smooth some texture lines throughout to maintain the glossy look of fur.

RENDERING TREES

Bark

Bark is a common element in animal drawings, since many species spend their time in forested areas. Follow these steps for rendering natural-looking bark in your wildlife drawings.

1. In this example of cedar bark, I use an H pencil to sketch a rough outline. This establishes the angle of the trunk and maps out where the branch snags away from the tree.

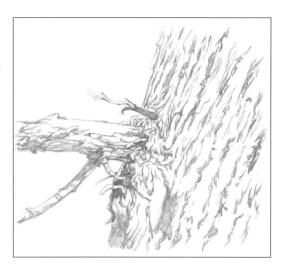

2. With a B pencil I use short, close strokes to create dark shadow areas (the negative space). I taper some of the blockier ends of the shadows into lines that extend along the branch or vertically along the tree.

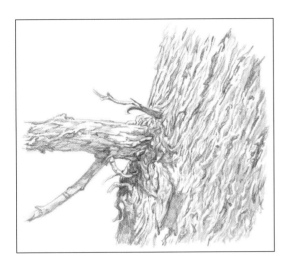

3. I use a 2H pencil to add texture and shading in the white areas between the shadows. I make long, curved lines for elongated sections of peeling bark and fill in around these lines with very fine, close strokes to establish a light gray midtone.

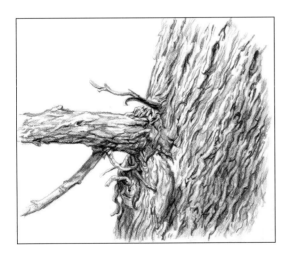

4. With a 2B and 4B pencil I darken the edges of the shadows. I also darken the bottom of the branch breaking away from the trunk and along the edges of the cracked bark to give further volume. The little broken twigs above and below the branch get extra darks pushed in as well, which helps lift them off the trunk. With multiple levels of shading that range in value with darks, medium darks, midtones, and highlights I have enough layers of texture and light to bring realism to the bark.

Pine Branch

Constructing an evergreen branch can be simpler than a leafy branch. Once you've sketched the general shape, merely apply straight strokes with varied pressure and length.

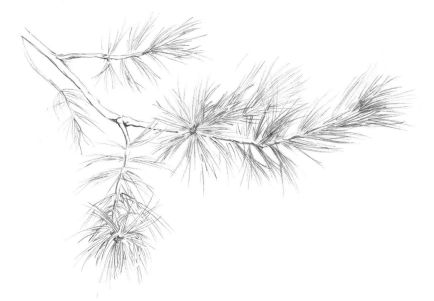

1. I draw in the basic arch of the branch with an HB pencil. Starting at various points along the branch, I loosely stroke in batches of lines for the pine needles, flaring them out. For a natural look, I twist and curve the strokes in various directions and place more clumps of needles in some areas, leaving gaps in others.

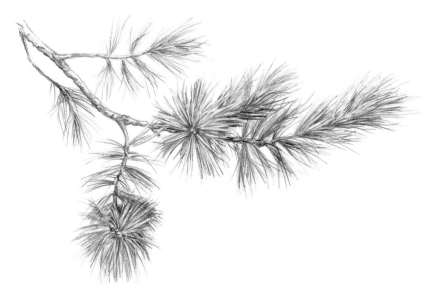

2. I add more lines in the foliage with an H pencil, lightly shading over the bigger clumps of needles. I also add more shading to the branches, bringing out lines in the bark and subtle shadows. Where the needles meet the twigs I add darker strokes, pushing hard with a 2B pencil and using less pressure as I move to the tips. I intersperse patches of dark strokes amongst areas of light throughout the branch. This helps the lighter lines pop out and the darker strokes recede, achieving depth, volume, and variety.

Maple Branch

Leafy trees are another common backdrop in a backyard or forest. To demonstrate this technique, I chose a maple branch as my model.

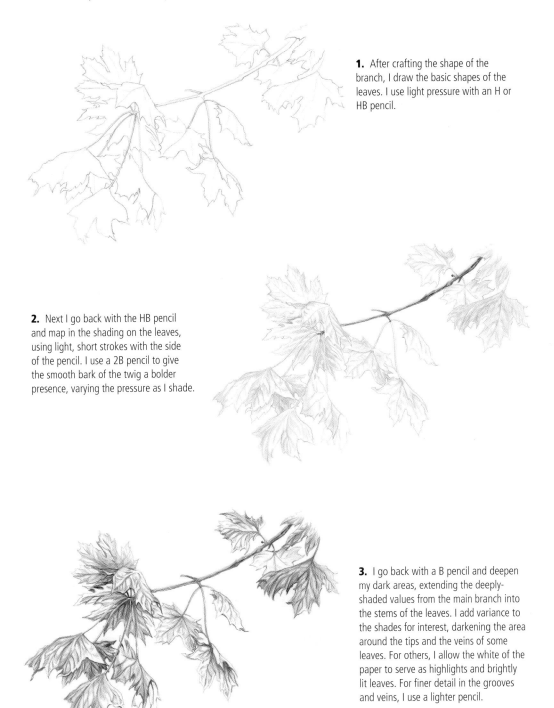

1. After crafting the shape of the branch, I draw the basic shapes of the leaves. I use light pressure with an H or HB pencil.

2. Next I go back with the HB pencil and map in the shading on the leaves, using light, short strokes with the side of the pencil. I use a 2B pencil to give the smooth bark of the twig a bolder presence, varying the pressure as I shade.

3. I go back with a B pencil and deepen my dark areas, extending the deeply-shaded values from the main branch into the stems of the leaves. I add variance to the shades for interest, darkening the area around the tips and the veins of some leaves. For others, I allow the white of the paper to serve as highlights and brightly lit leaves. For finer detail in the grooves and veins, I use a lighter pencil.

RED SQUIRREL

Smaller than it's larger cousin, the gray squirrel, the red
squirrel is found in naturally wooded areas. I want to capture
this critter's alert nature, so I chose a photo I took of one
perched upside down. The back leg of the squirrel is a
bit blurred, so I used another photo of a squirrel's foot as an
additional reference.

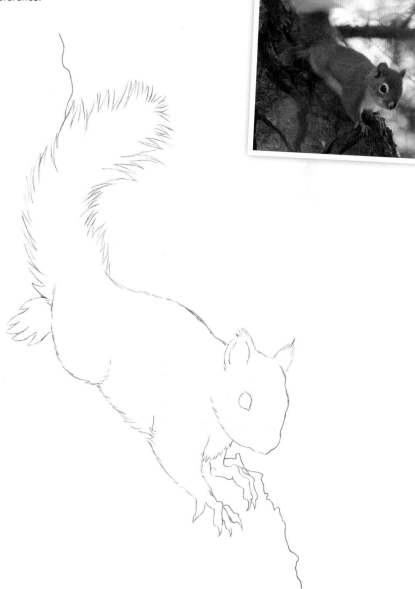

1. After drawing some initial basic shapes to get started, I lightly sketch the outline of the squirrel with my HB pencil. In
some areas, such as the bushy tail and furry ear tips, I leave gaps in my pencil strokes to suggest wisps of hair. I also draw
the wavy edge of the tree—just a bit above its tail and below its chin.

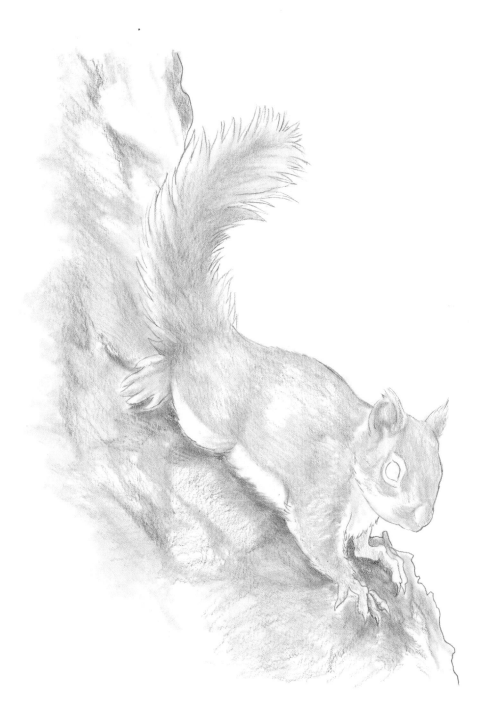

2. I gently shade in the outline with the side of my HB pencil. I leave some areas of highlights with just a bit of light shading, and I push a little harder in shadow areas. Then I blend with a stump, pulling the graphite from my pencil strokes into each other. This helps conceal the lines and soften the gray tones.

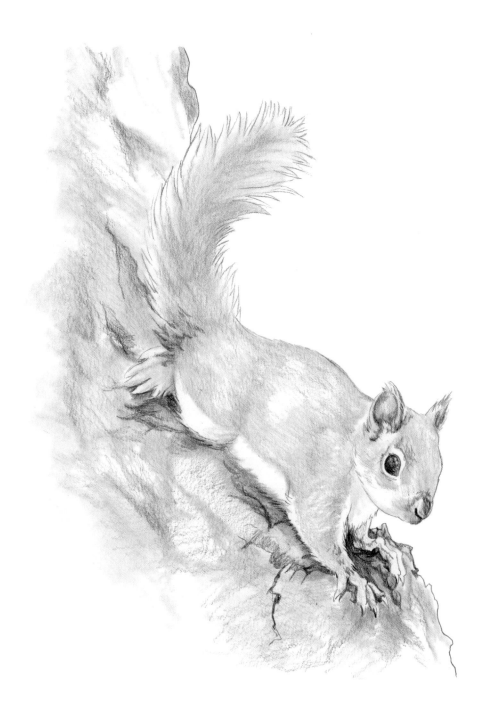

3. Next I identify the prominent dark areas around the squirrel, using a 2B pencil to apply darker graphite around the ear, eye, nose and nostril, and the areas under the hands and feet. Darkening the areas under the squirrel helps pop it up and away from the tree. Finally I add a few strokes to darken the fur at the base of the tail.

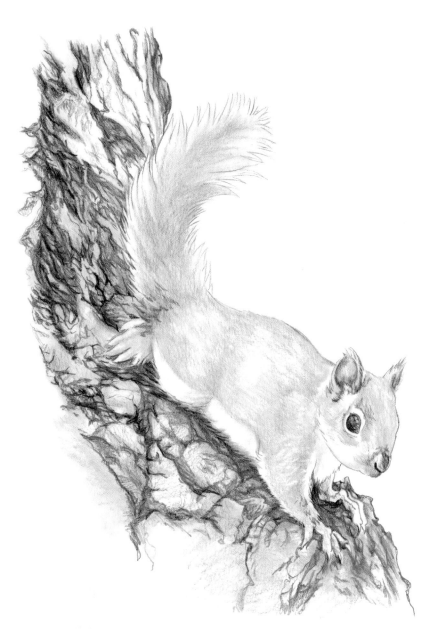

4. I switch to a mechanical HB pencil to draw the grooves and patterns in the tree bark. I model the look after my reference photo, but it doesn't need to be an exact replica. Then I use a 5B pencil to place dark values in the bark's fissures. I add shadows to the top two-thirds of the tree. I push the deepest blacks where bark overlaps. Varying the pressure I apply to my pencil while shading helps create multiple degrees of value in the cracks.

ARTIST'S TIP

Don't sketch uniform lines over the tail. Studying the subject reveals tiny shadows, overlapping hairs, and directional patterns in the fur that require subtle differences in line length and value.

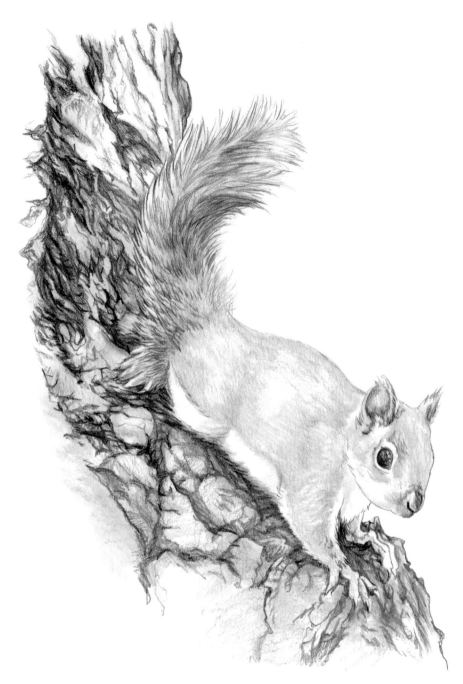

5. Before I add any more darks to the tree I need to determine how light or dark the squirrel will appear when I add detail work to the fur. I start with the tail and work down, adding pencil strokes to its bushy tail. I use a 2B pencil in the darker areas, such as the shadow in the curl of the tail, the tiny shadows in the overlapping tufts along the base of the tail, and the fur that winds into the back leg. I don't want the squirrel's fur to appear too dark, so I add the remaining detail with an HB mechanical pencil.

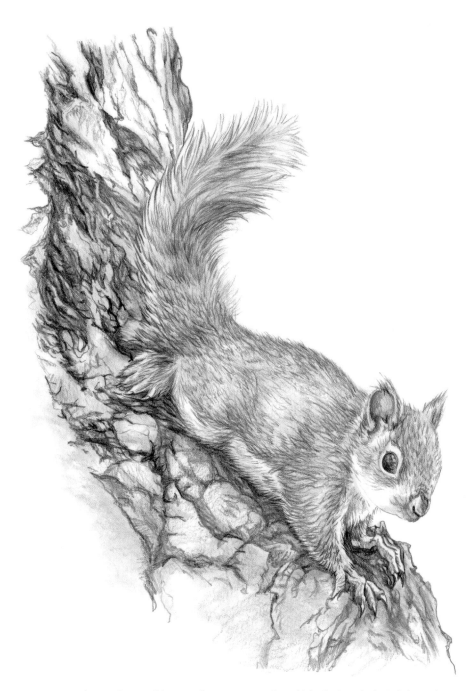

6. I continue working on the rest of the squirrel, using a 2B pencil to add detail where the fur is darker and a mechanical pencil to create finer strokes and add subtle patterns in the fur along the haunches, shoulders, and side. I shade darker areas under the fingers, little patterns atop the nose, and V-shaped patterns from the white eye-ring toward the forehead. I also use a series of dark strokes on the back front leg poking out from the white chest fur. I use finer, lighter lines for detail in the muzzle and face and the fur on the fingers. I use a combination of dark and light fur lines around the ears to help separate them from the head and neck.

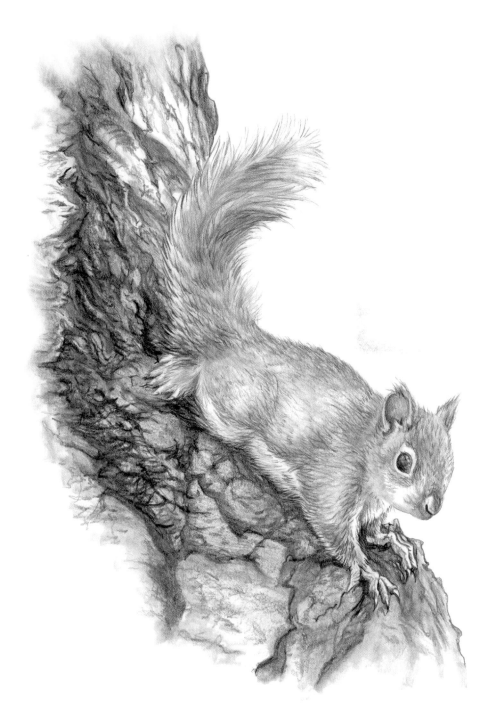

7. The squirrel blends into the tree now that he is detailed, so I turn my attention back to the bark. I use a dull 3B pencil to start darkening the trunk, varying the pressure and expanding the left edge of the tree with some additional shading. I leave a few areas untouched, but apply graphite to the rest of the tree. I use a blending stump to blur some of the shadows together, as well as the edges where my drawing stops. Then I sharpen my pencil and add more cracks to the bark, pushing hard for the darkest values where the bark disappears into shadow. I make the jagged fissure below the squirrel's elbow more prominent and add darker value to the bark under its right hand.

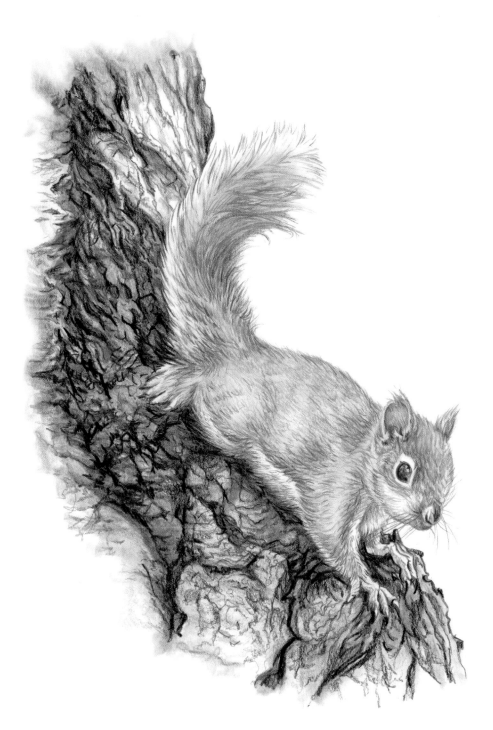

8. I use a 5B pencil to add more blacks to the tree, pushing the darks in the cracks. I sharpen the pencil often to ensure that the dark areas have skinny cracks as well as wider ones. I switch to a dull 3B pencil to add a few swirls, pressing lightly, on some of the less shaded patches of bark. Then I sharpen a 2B pencil and add dark strokes in the squirrel's fur where the shadows are deepest. I use fine, short strokes so I don't darken too much. I focus on the areas above the eye and around the ear, nose, armpit, and back of the neck. I add a few more swirling lines and fissures in the tree bark. Lastly I draw a few quick, dark dashed lines off the squirrel's nose for whiskers.

GRAY WOLF

The gray wolf is a fascinating natural part of the forest ecosystem, and capturing its elusive nature in graphite is an exciting challenge. I took this photo at the International Wolf Center in Ely, Minnesota, where there is a pack of wolves in a large, forested enclosure that can be viewed any time of year.

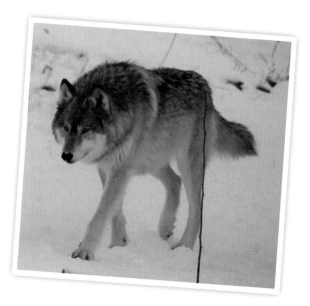

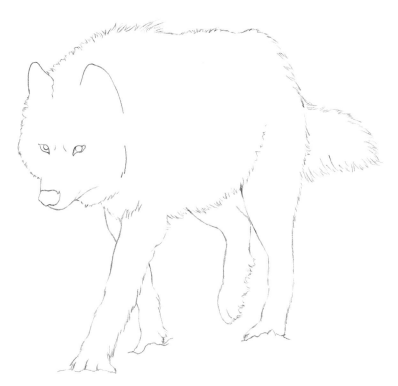

1. I start by lightly sketching an outline with an HB pencil. I don't worry about the details at this point, but I use short, curved, dashed lines along the wolf's body to suggest the shaggy ends of its fur. I also draw in simple shapes for the eyes, nose, and ears. Since a portion of the paws will be hidden by snow, I don't draw much of the feet.

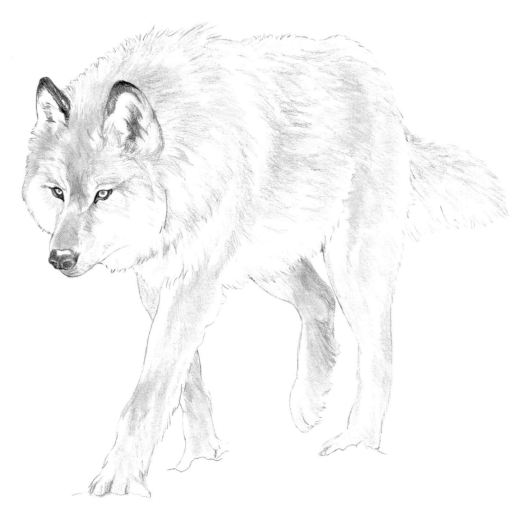

2. I flesh out the wolf's facial features first, since they will be reference points for surrounding detail. I use a softer graphite B pencil, varying my pressure on the pencil to attain a range of dark values for the ear tips and nostrils. I draw slightly lighter areas on top of the nose and the fur between the eyes. I also darken around the wolf's irises to give the predator a transfixing gaze. I switch to a dull H pencil to block in the large areas of lighter gray on the wolf's body. As I work, I stop occasionally to blend with a stump and soften the look of the fur, especially around the face and muzzle. I allow the white of the paper to show through on the cheeks, belly, underside of the tail, ears, neck, and above the eyes.

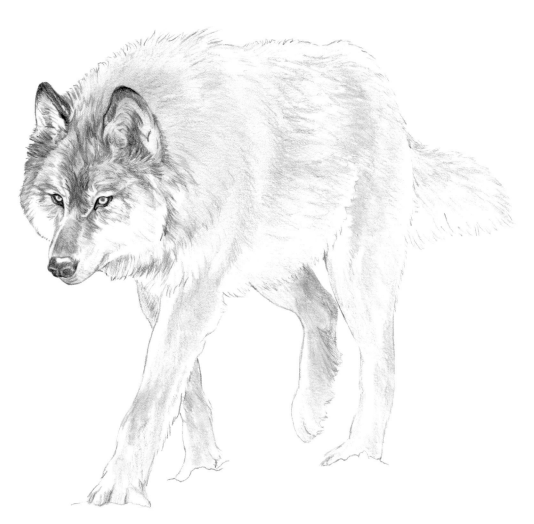

3. Next I begin to add detail. I switch to a mechanical HB pencil and start placing thin lines for the facial fur, starting at the chin and working up. The wolf's upper lip is darker just below the nose and lighter towards the cheek. The fur tends to part outward, starting between the eyes and moving toward the sides of the face and down. Following the length of the fur, I keep my pencil strokes short in the middle of the face and use longer lines as I work up to the top of the head, under the chin, and around the ears. I leave some lighter areas and press harder in others to give the fur depth and the illusion of layers.

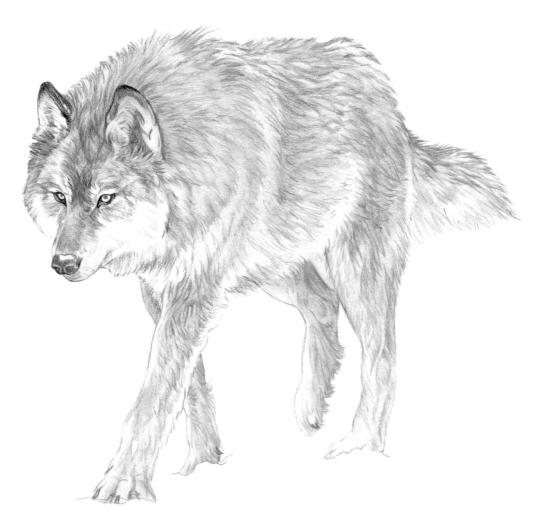

4. I continue working on the wolf's body, using the mechanical pencil to add pencil strokes that map out the varied length and direction of the fur. The fur is thickest in the body and tail, so I use long lines in those areas. As I work down the legs, I shorten my strokes and follow the fur's direction, varying the pencil pressure to create lighter and darker areas. The lighter areas help the fur "pop out" toward the viewer, while the darker areas suggest folds in the fur and the skin below. I add the tips of the toenails peeking out from the foot fur before moving on.

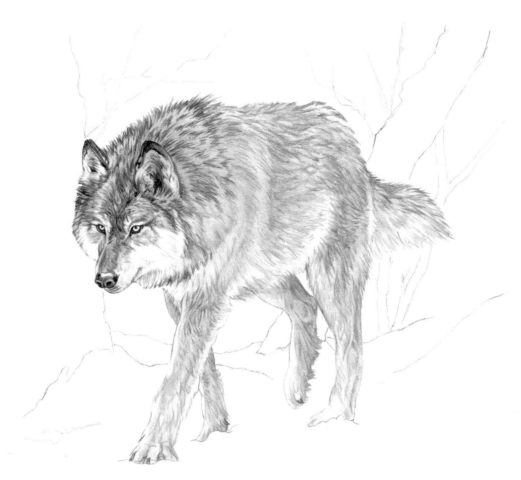

5. I lightly map out the snowy horizon line and a few trees poking out of the ground. Then I begin to add detail to the wolf's fur, starting at the face and working into the body. I use a softer graphite B pencil to add darker shading and dark strokes along the edges of the fur patterns. I enhance some of my previous strokes, but I don't draw too much over areas I have already covered. I want to add definition to the fur and darken areas where it overlaps, rather than re-draw all the fur from previous steps. I focus on the patches of dark fur along the back of the neck, the shadow area on the forehead, and especially along the border where the ears protrude from the head. I switch to a 3B pencil to push the dark values in the center of the ears and on the nose, so that these features stand out against the wolf's coat.

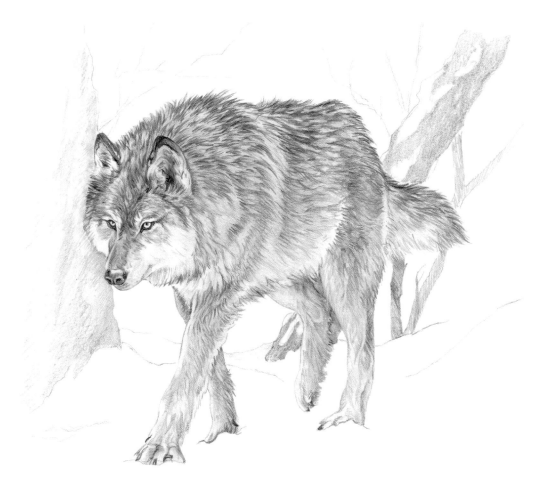

6. I continue darkening some areas of fur as I move back into the wolf, using the same process as in step 4. I leave areas of fur along the edge of the collar, the underside of the neck and tail, the shoulder, and the ankles unmarked. I continue to work in horizontal V-shaped and triangular patterns to show overlap of light and dark fur. I sharpen my pencil frequently. The cheek and muzzle are a bit too white, so I use a small blending stump to pull some of the darker shading from the face into the jaw. I use the side of my HB pencil to loosely shade the trunks of the trees in the background to give the trees some presence.

ARTIST'S TIP

The leaning tree behind the wolf provides a directional cue that leads toward the wolf's foremost leg, which helps move the eye from the background to the foreground.

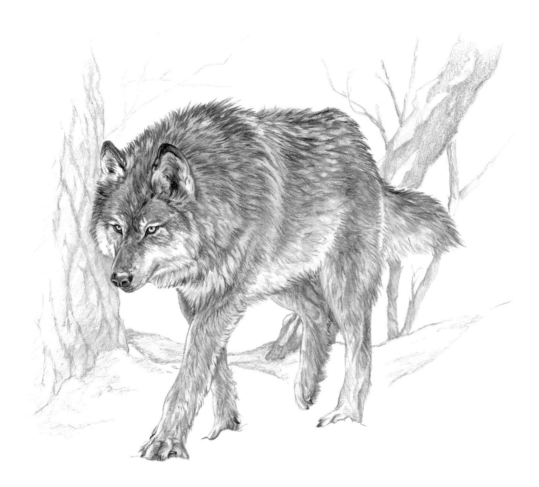

7. Still using an HB pencil, I create a grooved pattern in the pine tree to the left of the wolf's head. I also sketch in shadow in the snow behind the wolf's legs and add some detail and value to the background tree branches. Then I switch to a mechanical HB pencil and add fine pencil strokes in the wolf's light fur. I also add short strokes around the eyes, mouth, snout, and legs. I add a few strokes intermittently in the underbelly and tail fur to show some texture. I draw parallel strokes in the direction of the fur at the base of the cheek and behind the jawline. Finally I use a small blending stump to blend the distinct pencil lines on the wolf's mouth. The fur is so fine here that it is more realistic to show the shade, rather than distinct hairs.

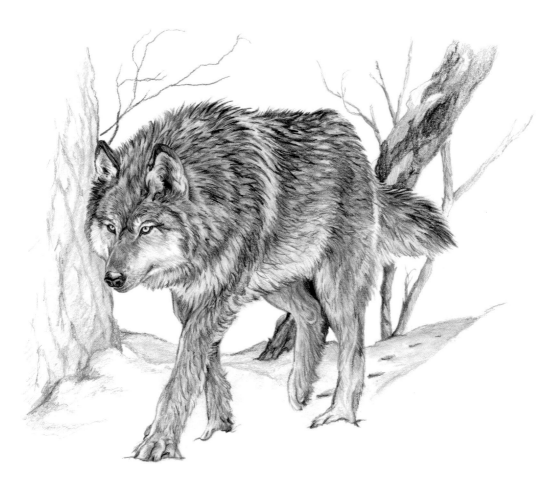

8. I add the darkest darks along the top of the wolf's back, tail, and neck using a 5B pencil to push the contrast. I also add dark tips to other areas of fur, such as the back of the neck. I'm careful to leave many unmarked areas where light hits the wolf or lighter fur pokes out. The variety of grays gives the wolf its lustrous coat. I push deeper darks in the nostrils and nose edges, the center of the ears, and between the front toes. I roughly shade some features in the leaning tree in the background and use a blending stump to blur hard pencil lines in the snow. Lastly I use my 3B pencil to make little divots in the snow that lead away from the wolf—his footprints! I leave the edges of the prints dark, but I use a kneaded eraser to lift out graphite from the centers to suggest cupped snow.

FOX KITS

I was elated when I came across a fox den with two young kits that put on a show for me. They fought and played, explored around the mouth of the den, and trotted over to look at me.

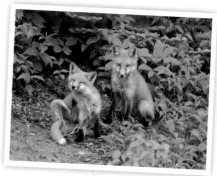

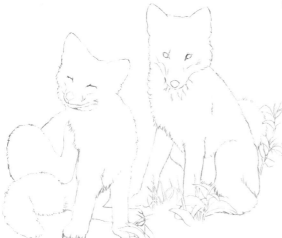

1. I start by drawing the outline of the two young foxes with an HB pencil, using tiny broken, jagged lines for the initial illusion of fuzzy fur. Notice how leaves break up the shapes of the foxes' paws. I block in the plants first and then add the visible parts of the feet.

2. I add general shading over most of the drawing with a dull H pencil, focusing on the bellies, lower legs, and under the chins. There are various areas of darker and lighter patches on the faces, so I shade more deliberately, darkening areas on the sides of the muzzles, in the outside corners of the eyes, on the foreheads, and in the inner ears.

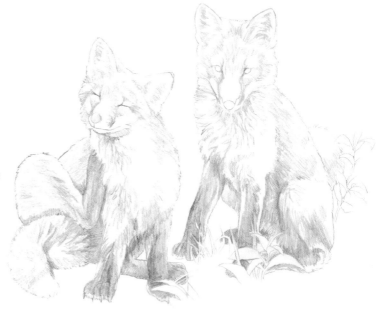

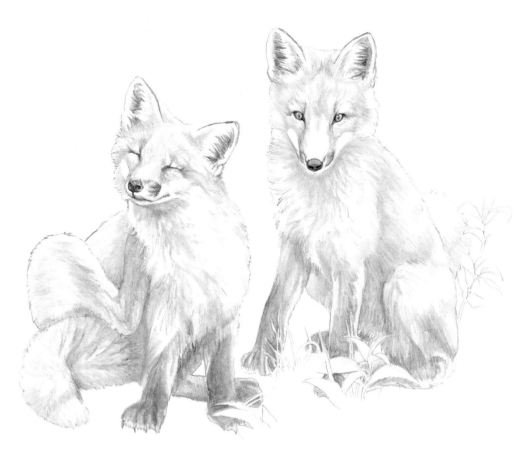

3. I use a large blending stump to smooth the pelts, dragging graphite from my shading into other areas. I still want to leave areas of light, so I don't blend over the entire image. I switch to a narrower blending stump for smaller areas like the forehead. Then I use a B pencil to begin detailing the eyes, ears, and noses. For the ears, I press lightly in the dark space that peeks out from behind fur. This contrast draws the viewer's eye to the ears—a striking feature on a fox. On the noses, I make the bottom values darker than the tops. I leave a dot of white in the middle of the pupils as I shade the eyes, and I try to vary the depths of darkness in the dark outline around the eyes. I also lightly shade the outside edge of the nose and along the lips of the fox on the left.

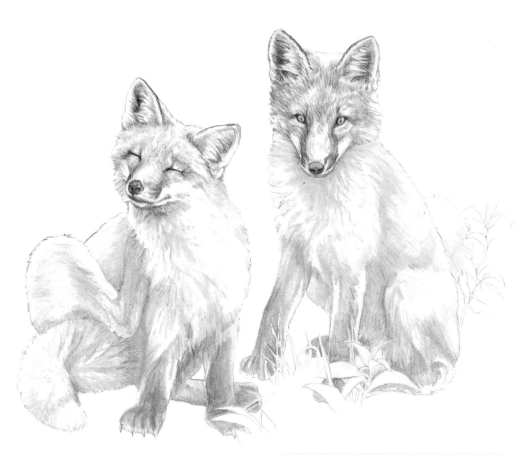

4. Next I focus on the faces, using a mechanical HB pencil. Note the direction the fur parts. Both foxes have fur that runs from the top of the nose up and over the forehead. From the bridge of the nose and around the eyes, the fur runs to the sides of the face. I vary the thickness and density of my lines as I work to create patches of lighter and darker fur. Between the eyes I use a "V" pattern to create subtle texture. I draw strips of parallel lines to form ridges of fur that contrast with light areas of less shading around the nose, the top of the head, and the fur that runs into the ears. I work on the ears from the inner edges out. Notice how the ear has a dark edge, followed by a light area before the gentle hollow with shaded fur.

Ear Detail

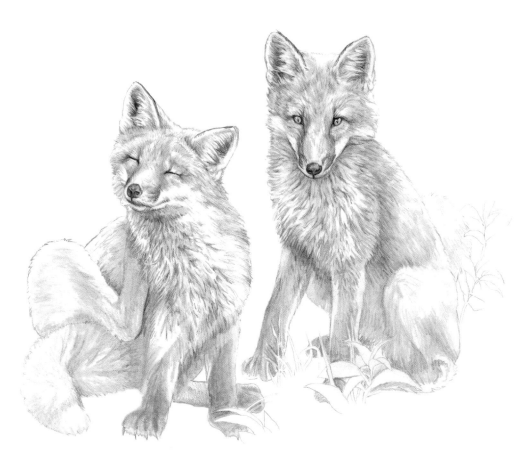

5. I continue adding fur with my mechanical pencil. The chest fur on the foxes is white, but contains shadows. I leave some patches of the fur very light or entirely white. I concentrate most of my shading on the left fox between the lifted back leg and the chest fur, behind the front legs, under the "double chin," and in wedge-shaped dark patches in the fur. Where the leg kicks behind the fur I use negative drawing to shade the dark spaces between the hairs, making the light chest hairs pop out. I add similar wedge-shaped areas of fur on the other fox, as well as dark areas under the rightmost armpit and between the chest and leftmost leg. I draw the fur beneath the chin a little darker to lift the head away from the chest. I use pencil strokes on the chest that radiate from around the muzzle. Then I very lightly smooth some of the lines in the faces with my blending stump.

Artist's Tip

Take time to notice patterns in fur. This is important in helping your subject look accurate and realistic when your drawing is complete.

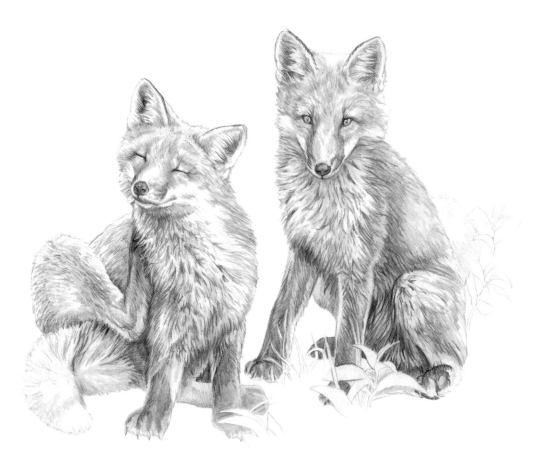

6. I use a 2B pencil to draw the bodies, upper legs, and haunches and reinforce shading in the chest fur and where the legs separate from the body. The belly fur of the fox on the right is longer and darker, so I elongate and press hard to make my "V" shapes. I use shorter strokes over the haunch of the crouched leg and the dark patch on its knee. Light hits his side, so I only shade above and below the hips and shoulder. I work on the downward fur pattern on the upper legs and roughly block in the back feet. I add dark edges to some of the chest fur. I darken the negative space by the back leg and neck of the left fox to further emphasize the contrast between the dark feet and the white fur on the neck. I add darker lines to the shaded patches in the chest and darken the belly to separate it from the tail. I add long, radiating lines to the base of the tail. Then I add patches of lines along the top of the legs, using longer to lines to suggest shaggier fur, breaking them up with patches of lighter color. I block in a bit of shading on the lower legs and then draw the fur on the back leg's haunch using short lines with a mechanical HB pencil.

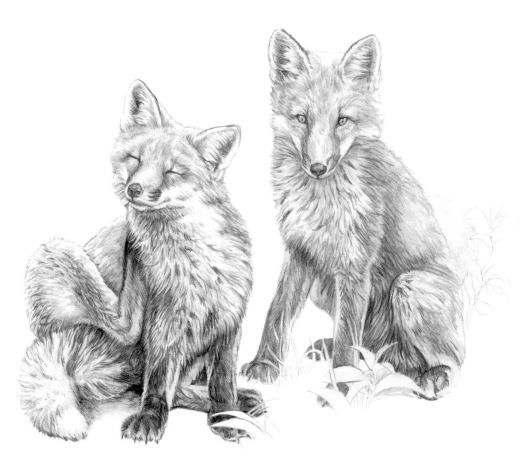

7. Next I work on the left fox, starting with the lower body. With an H pencil, I lightly create patterns in the tail fur with long, curved lines, leaving areas of white between them for the illusion of willowy fur. I use B and 2B pencils to further darken the shadows where the tail meets the body, and I add new lines that curve toward the kink. I return to the haunch with a 2B pencil and shade the underside of a few patches of fur with just a few strokes, pressing hard to darken the back paw and the area that separates the tail from behind the leg. Continuing to use dark strokes, I begin to create the dark "socks" by pushing with varying degrees of pressure. I use shorter strokes with less definition in my lines to separate the ankle and paw from the upper leg, and I use slightly lighter shading between the toes to differentiate them from each other. I shade a thin area along the bottom of the paws to ground them on the forest floor, leaving a white edge along the toes. Finally I shade the backmost leg with the darkest value, following the edge of the chest fur.

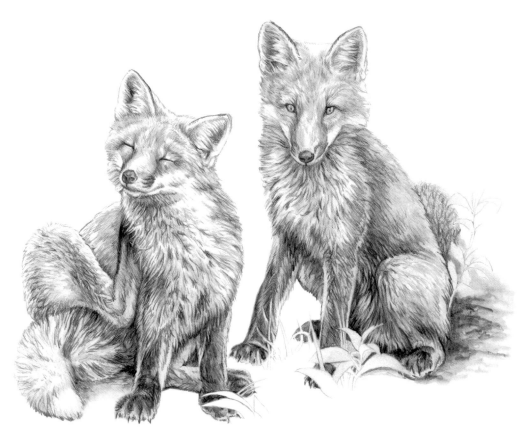

8. I turn my attention to the right fox. Starting with an HB pencil, I create a light, uniform shade on the pouf of the tail. I press a little harder to create a honeycomb pattern in the fur. Switching to a 2B pencil, I darken my shadows from previous steps in the bottom half of the fox. I add darker parallel lines in the lower legs and feet. I create new layers of shading in the armpit, along the side, and in the belly fur between the legs. I extend some of my shading with the 2B pencil from the back edge of the animal into the ground with rough patches of shadow to ground him in the scene. I use a blending stump to extend and fade out the shadow around the plant alongside the tail. Then I use a 4B pencil to push the deepest darks under the belly fur and where the tail meets the back leg.

Tail Detail

Try not to create noticeable
individual lines, because the tail
is part of the background.

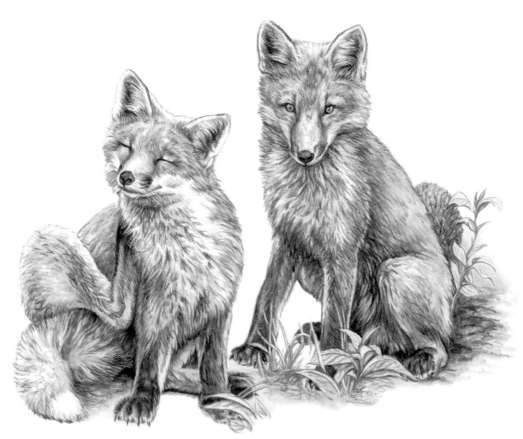

9. I use an H pencil to shade the rightmost fox's back-leg haunch with soft gray. I switch to a mechanical HB pencil and add a few wedge-shaped lines in the dark fur on its left. I add very light shading in streaks on the face, as well as a few more tiny stripes of parallel lines, from the tops of the eyes to the forehead and under the ears. I continue adding intermittent patterns of darker lines, from the edge of the eye along the back of the neck. I add light lines along the edge of the mouth, and I sharpen the ear. On the right fox I add a few lines to deepen texture, and I add more pattern in the tail. I add a few lines in the chest fur, and I use my HB pencil to draw subtle patterns on the forehead. I draw darker "V" shapes below the ears and between them. I darken the area between the eyes with tiny lines. Lastly I use H and HB pencils to add subtle shading to the plants and a little shading under the left fox. I use a 2B pencil to darken areas that could use more value. To finish, I cut a small wedge off my rubber eraser and use the point to erase tiny bits of graphite from the edges of chest fur on the right fox to create contrast. I use the sharpest corner to flick away a little graphite from the muzzle to suggest fine whiskers. I dab a few areas with my gum eraser to lighten, such as the neck and chest of the fox on the right.

RACCOON

The raccoon is one of the forest's most recognized inhabitants. Its ability to find food from creeks, birds' nests—and even campsite coolers—showcases its cleverness. I chose this photo of a raccoon walking out on a pine branch because it's a great image of the face, surveying the viewer with intelligent, beady eyes.

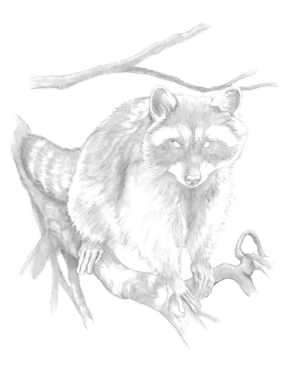

1. I draw a simple sketch with my HB pencil, but I perk the ears a bit more and make the tail visible. Then I use the edge of the pencil to shade darker fur and bark, as well as areas of shadow. I use a large blending stump to pull graphite from my pencil strokes into each other to blend, focusing on the lines in the branches, where I want the strokes to disappear the most.

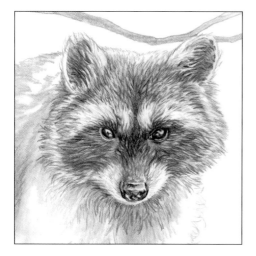

2. I use a 2B pencil to shade the eyes, leaving white reflections. I shade the bottom and top edges darkest and use midtones to create reflective shapes. I create the "lip" of the lower eyelid and tear duct before drawing groups of light and dark fur in the mask. I switch to a mechanical HB pencil as I move down the nose, using shorter pencil strokes. Using fine strokes, I shade the nose. Then I switch to a 2B pencil and add dark edges along the nostrils and nose edges, leaving some white areas. I continue drawing the fur around the head with a B pencil, following the direction of fur growth, pressing harder in the inner ears. I use a finely-sharpened 2H pencil to add fine detail to the lighter areas in the face.

ARTIST'S TIP

Animal noses look more realistic if you draw what you see instead of "correcting"
the nose and adding two prominent nostrils where you think they belong.

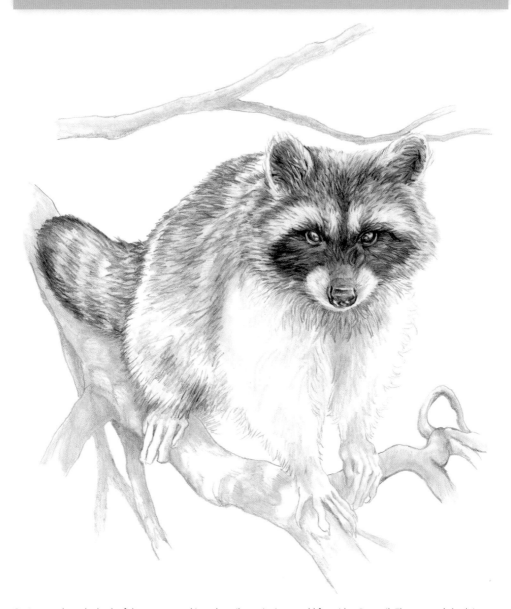

3. I move along the back of the raccoon and into the tail, continuing to add fur with a B pencil. The raccoon's back is mottled in color, so I leave some areas light and push dark pencil lines into others. I want a streaked appearance, while still maintaining the texture of fur, so I continue making clumps and sideways "V" shapes. I use little gaps and pencil streaks to break up the shapes and create a jagged appearance. Then I use a small blending stump on the face to smooth lines. I also fade the texture in the eyebrow area by pressing my kneaded eraser and lifting out graphite to lighten areas. I reinforce the mask, forehead, and dark areas around the ears with a 4B pencil.

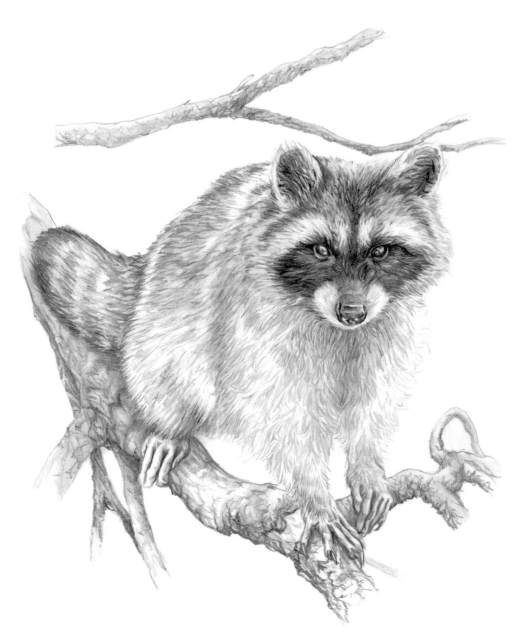

4. I work on the curly fur on the chest and arms with an H pencil, pressing lightly to draw clumps of lines. I press harder in the chest fur and inner arms, where there is more shadow. Then I switch to a mechanical 2H pencil to draw finer, lighter lines to introduce individual hairs. I start creating texture on the branch with an HB pencil, using a reference photo for cues on bark patterns. I press hard enough to create new dark values, but not so hard that the branch begins to compete with the animal. Where light inner bark is exposed near the raccoon's right hand, I use a B pencil to add a shaded edge to the surrounding outer bark. I also add a few areas of darker values to the underside of some branches and draw the creases between the raccoon's fingers. Then I use an HB to create the subtle details around the nails and knuckles, using small, light strokes. I leave a bit of white at the top of the fingers to catch light. I use my smallest blending stump to blur the strokes into a smooth, skinlike appearance.

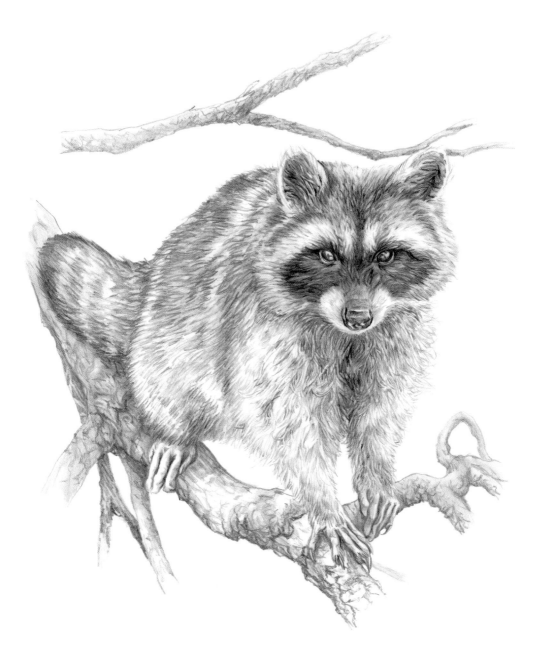

5. Now I add additional darker shades of gray to the raccoon's body fur, which help make the lighter areas "pop" and create a more natural transition in values. I use a B pencil to darken the area between the arms, using sweeping and irregular pencil strokes that follow the direction of the fur. As I work toward the left elbow, I only draw a few darker patches where the overlapping fur creates shadow. I follow the existing fur patterns on the raccoon's flank, leaving some areas alone as I introduce some darker strokes to give the pelt more depth. I focus on adding darker sets of lines just behind the cheek fur and right shoulder to help pop the head away from the arm and the arm away from the body. Then I work in some darker areas just above the back foot, and I use a 4B pencil to add small patches of dark fur between the arms.

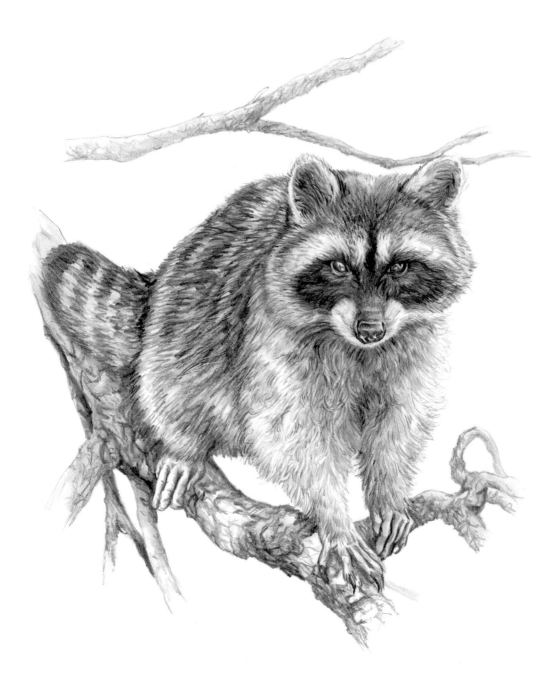

6. Now that the largest areas of texture and the light and midtones are set, I shade the darkest values. I use a 6B pencil to draw streaks of black between patches of fur on the raccoon's sides and where the tail intersects with the body. I shade between the eyes and under some patches of fur in the mask to make the face bold—and the focus of the drawing. Adding a few lines of dark graphite on either edge of the ears, under the nose, and between the bottom edges of the branches allows sections of the scene to emerge as background and foreground. I use a 2B pencil to darken some of the areas between my deepest blacks and lighter grays to bridge the values. I particularly focus on adding this new shade of gray to the bands on the tail and in the mottled side of the body. I use an HB pencil to create a bridging shade of gray on the branch.

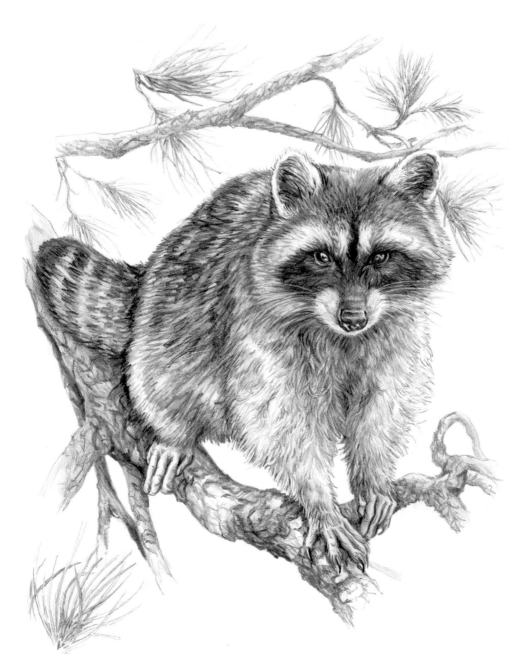

7. I use an H pencil to add clusters of pointed pine needles. I create a little shading at the needle bases and on the undersides of some needles with an HB pencil to create subtle dimensionality. I extend skinny twigs to connect the needles to the branches and continue shading the underside of the twigs to create scaly texture. I push 6B darks behind the haunch of the back leg and at the tip of the tail. I darken the areas between the fingers and the branch behind the front paw. I also work an occasional dark stroke into the tail bands, darken the fingernails of the outstretched hand, and push a few areas within the ear. I push the deepest blacks around the reflections in the eyes and create a very dark shadow just above the eyes. I add tiny strokes of black here and there to suggest pockets in the fur that the light doesn't reach. To finish, I cut an edge of my rubber eraser to an angular point and erase tiny lines from the edge of the nose out, creating whiskers.

BLACK BEAR

Drawing this black bear as a head-and-shoulders portrait will help capture the personality in the face. I took this photograph of a captive bear eating grapes, looking around as he ate. I was taken by the emotional depth in his eyes. To give my drawing a more natural appearance, I decide to replace the store-bought grapes in the photo with wild raspberries.

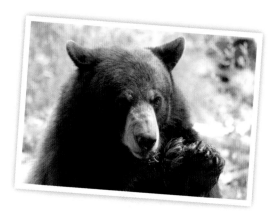

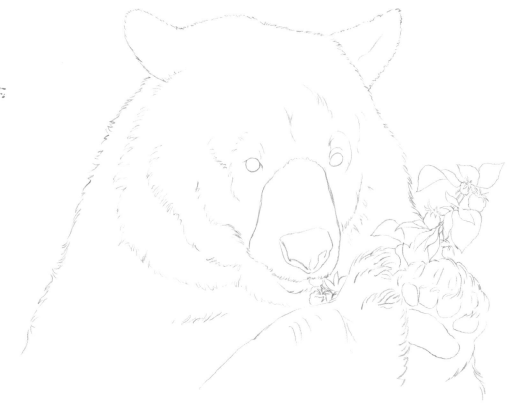

1. After sketching out the basic shapes to plan my composition, I sketch the outline with an HB pencil. The overall shape of the black bear's shoulders, neck, and head is a like a wide gumdrop with shaggy edges. The snout is another lumpy gumdrop, and I sketch in the placement of its nose, paws, ears, and the berry branch with a minimal amount of detail.

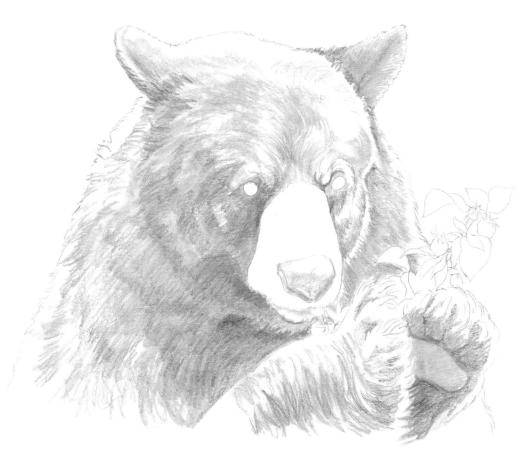

2. Rendering a black bear requires extensive dark shading. To map out the various areas of lighter and darker values, I begin blocking in shades of gray with a dull B pencil. I'm not too worried about creating or avoiding texture in this step; I just want to put down some values. I pay attention to the direction the fur runs and follow those directions with my pencil strokes. For example, the fur parts down the middle at the top of the nose and runs front to back with wavy strokes. The fur along the paws runs downward to the bottom of the feet.

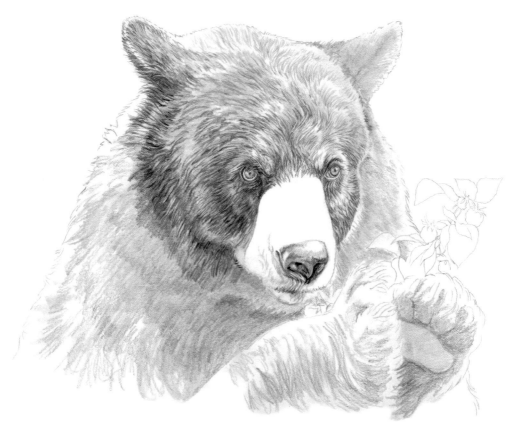

3. I smooth my pencil lines with a stump. Then I sharpen a B pencil and draw the darker fur around the eyes and the dark lines around the irises. I use a 2B pencil on the nose, pushing hard for the dark corners of the nostrils. With small strokes, I draw the lines of fur near the bottom of the nose and on the left corner of the mouth. I use an HB pencil to draw some of the finer detail in the eyes and the surrounding fur. I also draw the fine eyelashes. With a dull pencil tip, I gently shade the brown irises, leaving a white spot of reflection. I shade areas of light reflection on the nose, pushing harder and softer for variety.

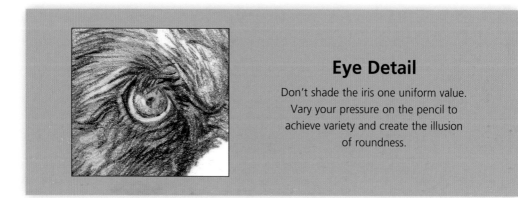

Eye Detail

Don't shade the iris one uniform value. Vary your pressure on the pencil to achieve variety and create the illusion of roundness.

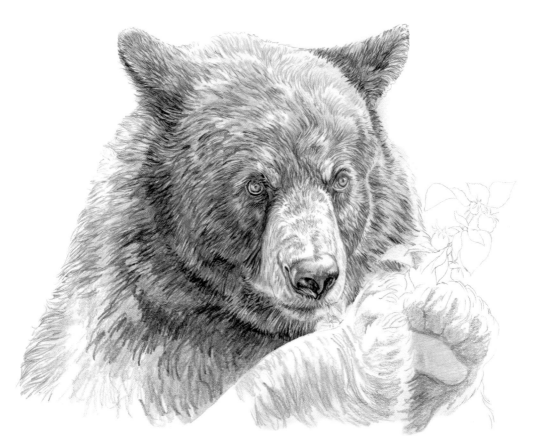

4. I use an H pencil to lightly sketch the fur running up the snout. Then I sharpen the B pencil and add dark lines where layers of fur overlap. I use short strokes and merge them into V-shaped points, paying attention to the direction of fur growth in my reference photo. I use less pressure where there is reflection in the dark fur, such as above the left eye and around the right eye. I also use an H pencil to add texture to the highlight areas. Where values are deepest, such as along the jawline, under the ear, and below the left eye, I use a 2B pencil. I add fur to the neck and ears, alternating between dark and light areas to help define the jaw and cheeks. I use wider, less fine-lined strokes as I work away from the eyes and nose. Doing so keeps the focus on the face and expression.

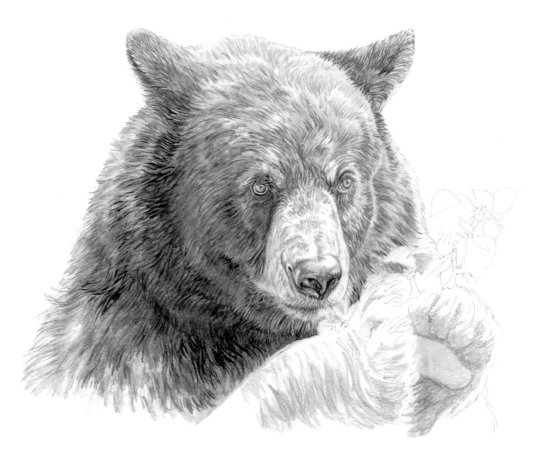

5. I use a blending stump to meld some of my lines together and "soften" the fur, which looks coarse and bristly. This mixes my grays a bit more, giving the animal a more uniform coat. I focus my blending on the left ear and side of the face and the area running from the neck to the shoulder. Then I pick up my darkest pencil, a 6B, and begin to lay in some black values in the fur where the shadows are deepest. Continuing to follow the patterns and direction of the fur, I add a lot of deep values to some of the darker areas where the head and neck meet. Dark shading here will "lift" the head off the page, and I can bring some lighter patches of fur and the face of the bear closer to the foreground, while the areas of darkest value recede.

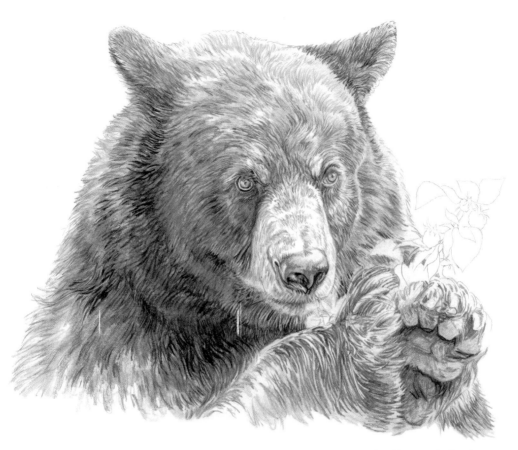

6. The fur on the paw is longer and consists of thicker individual strands. I use an HB pencil and focus on shading the area between the fur—the negative space. The area I don't shade pops out to form the shape of the individual strands of fur. The fur on the leftmost paw sweeps toward the bottom of the page before curving toward the end of the paw and crisscrossing around the claws, which are mostly hidden by overlapping hairs. I leave some sickle-shaped white areas here where the claws peek into view. I want the pads on the other paw to appear smooth, so I shade them with lines close together to avoid a hairy look. I use a 4B pencil for the dark areas between the individual pads. I also leave white space to map out the claws.

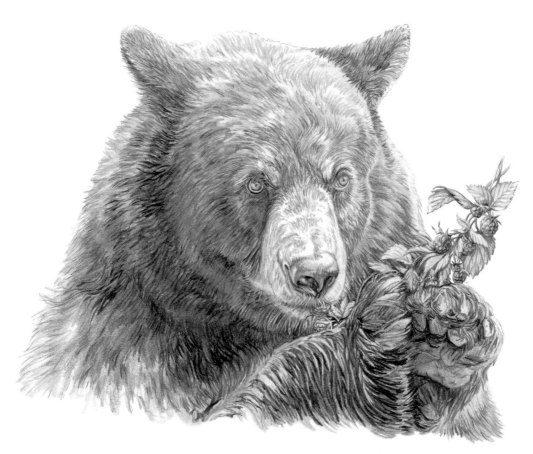

7. I use a 2H pencil to lightly draw the veins and serrated edges of the raspberry leaves. I also draw the bumps in the berries, shading the bottom right edges and leaving a lighter value on the tops. Then I use my 2B pencil to trace the bottom right of the berries. To create more value, I use an H pencil to add shading to the leaves. To keep the texture smooth, I use a small blending stump to eliminate most of my strokes. I use a B pencil to darken the areas at the bottom of the leaves, on the underside of the berries, and in the space between the leaves that overlap the bear. Next I use a 4B pencil to push deeper darks in the paws, especially where the two paws meet, at the base of the claws, and between some of the overlapping fur. Then I use a very sharp B pencil to create finer lines in the hair overlapping the claws.

Berry Detail

Shade the large leaf on the right
side lightly to help give the leaves
some dimension.

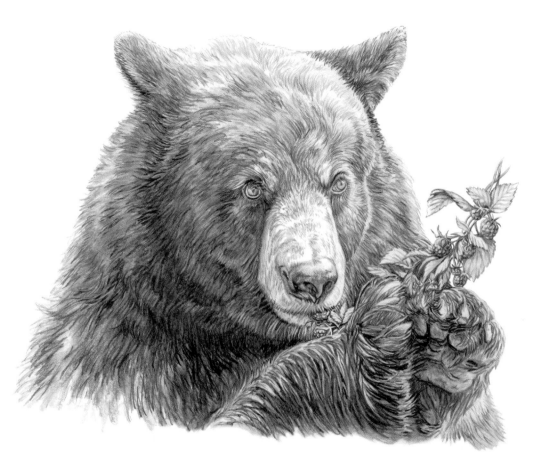

8. I smooth the fur with a blending stump, moving it in the direction the fur grows—almost like brushing it! I don't want to lose all the intricate line work I created, so I only blend the areas that I think it could benefit, such as the light fur of the forehead and in the leftmost paw. Then I use a 6B pencil to refine some line edges and push a few darks to set the bear's features apart from one another. I darken the bottom of the jaw and add darker fur texture to the left side of the face and in the neck. Next I refine some of the coarser hairs on the paws and deepen the existing dark areas more. I sharpen the pencil to a point and add very thin lines to darken the areas of fur around the eyes, just highlighting the underside of the hairs and eyeball. Finally I use a 2B pencil to darken some of the areas of shading within the ears, following the patterns I already created. I also darken a few of the shaded areas on the nose to create more contrast. The finished illustration has multiple shades of gray throughout the bear's coat of fur, giving it depth.

TWIN FAWNS

Finding a newborn fawn curled up in the leaves is one of the most delightful surprises the forest offers hikers in the spring. I was lucky enough to spot one and snap some pictures. I only saw a solitary fawn, but because they are often born as twins, I decided to arrange a composition of two young deer. I used several photographs of the same fawn from different angles to create my composition.

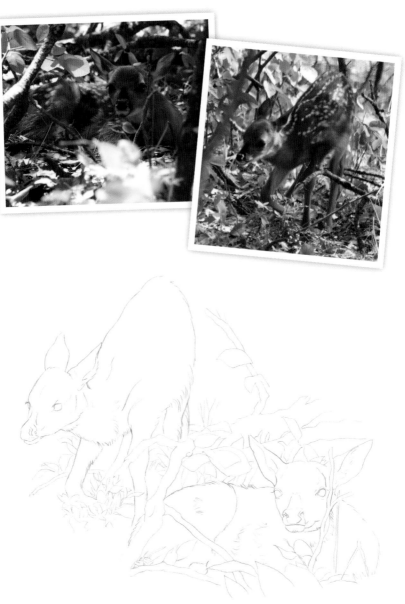

1. This initial sketch is more complicated, since it includes the details of the forest floor. I start by drawing the outlines of the two deer and the fallen branches with an HB pencil. These shapes help me see how the objects relate to each other and act as anchor points. I loosely sketch in the outlines of foliage and add very general detail on the deer—just some markings on the noses and eyes and directional lines for the fur.

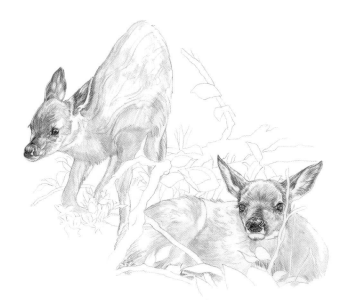

2. I block in shading, using an HB pencil for darker areas and an H pencil for the top edges. I use light coverage and leave some white areas where I will place white spots. I blend with a stump, giving me nice gray value to draw on. Then I use a B pencil to draw the darkest features—the noses, eyes, and ears. I use an HB pencil to create a V-shaped pattern on the top of the muzzle and ears of the fawn on the left. The fur on the ears is even finer, so I use the edge of the pencil to disguise my strokes. I repeat this detailing on the bottom right fawn, but I emphasize more of the lines because this deer is a little closer to the viewer. I darken the negative space around the white inner-ear fur. Then I use a 2H pencil to lightly mark white spots on the fur.

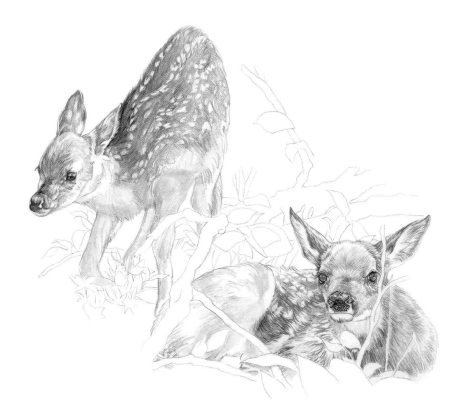

3. I shade the negative space between the spots with a dull H pencil, as well as the areas along the back, shoulders, and side of the top left deer. I use an HB pencil to create darker values in the shading and add dark fur along the shoulder and other areas to suggest textured patches. I switch back to an H pencil to shade the non-white areas on the bottom right fawn's neck, chest, and side. I leave the throat just below the chin white. Then I use a mechanical HB pencil for sharp lines to add the patterns of fur in the shading. I push harder in the deeper shadows under the haunch of the back leg and between fur patches at the base of the neck.

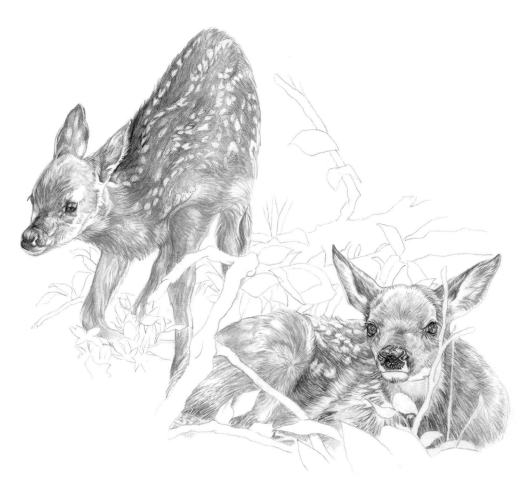

4. I continue to fill in the lighter fur, beginning with the left deer. I use 2H and H pencils to draw downward, fanning patches of fur that stretch from the chin along the neck and chest. I use the 2H pencil to draw jagged-edged patches, making the point darker, followed by lighter patches. I use a darker pencil to shade areas just below the chin, the edge of the white throat, and along the top edges of the legs. I use the 2H pencil to create subtle patches of lights and darks in the fur above the legs, working toward the feet and stopping at the hooves. For the right deer, I mostly focus on creating light fur in the back haunch, using the 2H pencil to create fine, lighter strokes that contrast with the darker fur. The fur radiates from a focal point just below the knee, so I use that as a cue when creating the direction of my lines. I also add some fine detail lines to some of the lighter areas I created in step 3.

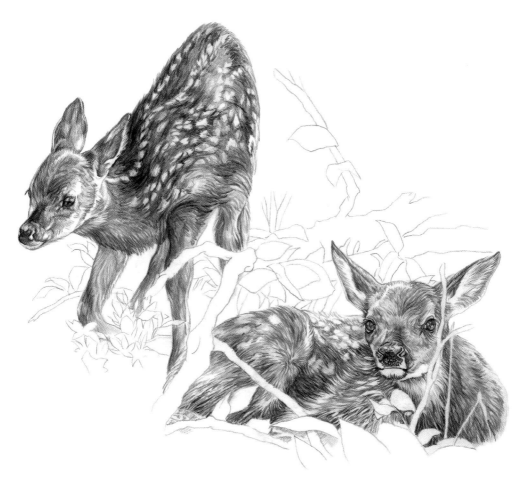

5. To create greater variation between the lights and darks—and give the bodies more depth—I use an HB pencil to push the already dark areas. To further emphasize the darks on the left deer, I push especially hard along the nape of the neck and the deer's side and back. I switch to a B pencil to push the darks further in the area of the back just below the ear. Since the lines in the right deer's fur are more pronounced, I use a mechanical HB pencil to maintain the fine line quality. I reinforce the darker values, but still leave room between pencil strokes and fur patches to maintain the texture. Having areas of light fur peek out from the dark patches creates the feeling of layered fur. I also draw some tiny dark areas, filling in the negative space behind the lighter fur at the base of the neck. I add shading to the forehead and around the ears to help define the shapes.

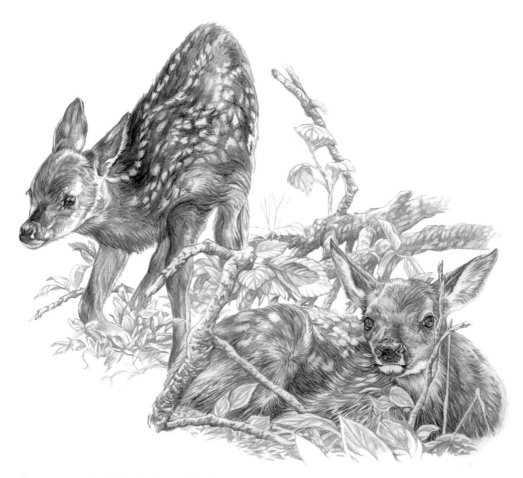

6. I use a 4H pencil to lightly shade most of the branches. Then I use 2H and H pencils to create patterns in the bark. I leave a white "lip" on the edges of the sticks to help them stand out from the darker values of the deer behind them. I use the dull 4H pencil to shade between the leaves' veins, leaving lots of white space. I shade the area more completely where a leaf is curled over or partially covered. I also add shaded shapes and blocks of light value between and below some leaves. Drawing this negative space helps give the foliage a full look, without having to draw every leaf and twig. I shade the area below the bottom right fawn in the same manner. Then I sharpen my pencil and add little lines in the larger leaves to create the veins.

ARTIST'S TIP

To avoid wood detail overtaking the focus on the deer, shade lightly and with minimal detail.

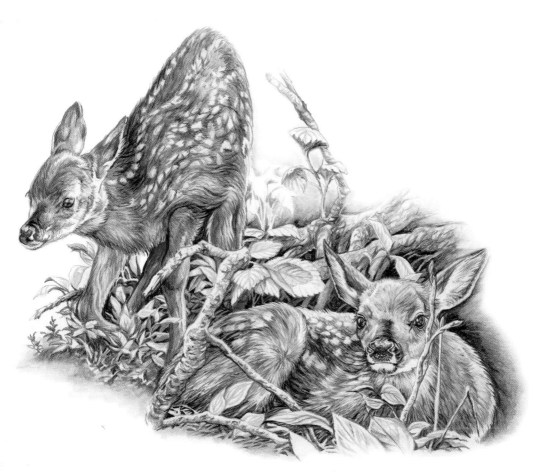

7. I use a 4B pencil to create extremely dark values between the branches and leaves behind the deer. I push my darkest values in the center of the drawing, just above the foreground fawn's back. I transition to lighter values, still pushing hard with my pencil, and eventually switch to a 2B pencil for the very edges of the dark background so the value doesn't come to an abrupt stop. I use a kneaded eraser to fade out some of the lines. Then I use a 2B pencil to darken areas of shading in the fawns' noses, ears, and eyes. On the left fawn I add darker lines below the throat and at the top of its left leg. On the right fawn I darken the shading on its side, where the back leg covers some of the body. To finish, I use a B pencil on the background to add a lighter level of shading on top of some of the branches and leaves. I also create some subtle abstract areas of vegetation on the far left to help with the composition's balance. Then I use my pencil to push hard on the edges of the branches that overlap the fawns. Finally I use a blending stump and my kneaded eraser to blur the lines at the edge of the background and lift out excess graphite.

CLOSING THOUGHTS

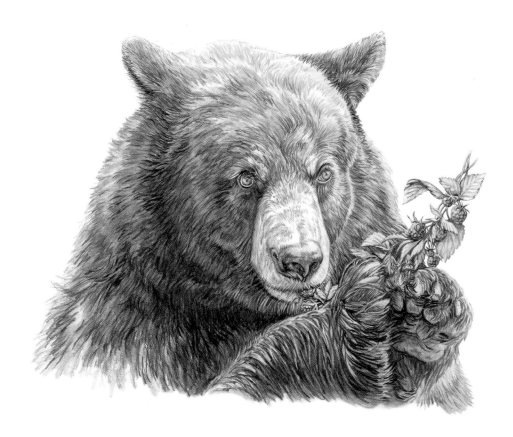

Drawing forest animals can seem challenging, with the various textures and subtle details that need to be rendered with just pencils. But this challenge can be fun—and the subject matter interesting and rewarding to work on. Start simple, with the shapes of the animals, and work on just one section at a time. Break up the drawing into steps, and what at first seems daunting will quickly become much more simple. Remember: Not every strand of hair or whisker needs to be drawn in order to create a lifelike rendering. Look for patterns in the fur and for areas where light reflection requires white space on the paper. Try adding trees and foliage in the background to place the featured creatures into a setting. Be observant, take your time, and enjoy bringing the secretive denizens of the forest to life in your drawings!